ABSTRACT FROM

ABSTRACT FROM THE CONCRETE

DAVID HARVEY

Sternberg Press

**Harvard University
Graduate School of Design**

Invited by MOHSEN MOSTAFAVI

Hosted by SENIOR LOEB SCHOLARS PROGRAM

Introduced by SUSAN FAINSTEIN

Interviewed by MARIANO GOMEZ LUQUE

 DANIEL IBAÑEZ

Produced by SHANTEL BLAKELY

Edited by JENNIFER SIGLER

 LEAH WHITMAN-SALKIN

Designed by ÅBÄKE

Printed by PETIT SK LUBLIN, POLAND

Published by HARVARD UNIVERSITY

 GRADUATE SCHOOL OF DESIGN

 STERNBERG PRESS

March 28, 2016
Piper Auditorium, Gund Hall
Harvard University Graduate School of Design
Cambridge, Massachusetts, USA

SUSAN FAINSTEIN It gives me great pleasure to welcome David Harvey back to Harvard. David is a Senior Loeb Scholar here at the Harvard University Graduate School of Design, and Distinguished Professor of Anthropology and Geography at the Graduate Center, City University of New York. He's also taught at Johns Hopkins University and was the Halford Mackinder Chair at Oxford University. (*Pause.*) I think it's fair to say that, beginning in 1973 with the publication of *Social Justice and the City*, David Harvey revolutionized the discipline of geography and brought a spatial understanding to the associated disciplines of urban studies. He did this by applying Marxist analysis to the study of the city, but also by injecting the notion of the city into Marxism, which had lacked a theory of physical and social space. His long list of publications includes, among many others, books on environmental justice, neoliberalism, the transformation of Paris, the development of urban consciousness, and Marx's *Capital*. In linking the question of social justice to urban development, Professor Harvey has broadly influenced multiple disciplines concerned with the physical, social, and economic development of cities. His study of Henri Lefebvre's "right to the city" is of crucial

SUSAN FAINSTEIN importance to the design professions that are represented here at the Harvard GSD. Please join me in welcoming David Harvey.

DAVID HARVEY I want to start with a simple fact, which astonishes
me. Between 1900 and 1999, the United States
consumed, according to a US Geological Survey,
4,500 million tons of cement. Between 2011 and
2013, China consumed 6,500 million tons of
cement. So in three years, the Chinese consumed
nearly 45 percent more cement than the United
States had consumed in the whole of the
preceding century. That magnitude of spreading
cement around is unprecedented. Those of us
who live in the United States have seen plenty
of cement used over our lifetimes. But what has
happened in China is extraordinary. And you can
just imagine what some of the environmental,
political, and social consequences might be.
So the question I want to ask is:

Why did this happen?

I should make clear, lest I be misinterpreted, that
if this fact elicits some critical commentary on
my part it does not mean that I am anti-Chinese.
I have to say this because in these times there
is a tendency to explain what is happening in the

DAVID HARVEY world in terms of national rivalries and the goods
and bads of national behaviors and policies. In
the political world of the United States, China
is frequently blamed for many of our problems
(loss of jobs, unemployment, and the like). The
fact that this huge use of cement occurs in China
is incidental to my argument. Though I do not
exculpate state policies entirely, the problems
that arise are primarily those generated out of
the contradictions of capital. I am anti-capital but
not anti Chinese. (*Pause.*) I also want to signal
a mild complaint about how the social sciences
work these days. When I first got into academia,
we were obsessed with the question "why?" We
spent a lot of time on that question and we often
made some pretty flamboyant and speculative
guesses—sometimes, I must admit, far-fetched
and totally unsubstantiated, and in some
instances arising out of a rather dogmatic Marxist
reading of capitalism's history. But since the
1970s, there has been a gradual shift of emphasis.
Less and less do researchers ask "why?";
instead, they ask, "how?" and "where?" (*Pause.*)
Concentrating on the "how and where" leaves us
much better equipped to unravel the intricacies
of *how things happen*. It frees us from the chains

DAVID HARVEY of dogmatic assertions. We no longer presume some grand explanation, like the compelling force of class struggle or crude functionalist theories of state action. Instead we describe in detail how it is that, say, developers get together with lawyers and construction companies, with financiers, landowners, and state officials, to launch fantastic megaprojects that require a lot of cement even as they spark protests from evicted homeowners and tenants from this or that space in the city, as well as from citizens in general, who believe it would be better to spend money and resources on more socially beneficial investments. We pay far closer attention to local conditions. We are much more sensitive to cultural and environmental differences. The "where" matters. But it also has some perverse consequences. It introduces national character into the debate (as in the case of Greece) in ways that can mask what the underlying dynamic of endless capital accumulation is about and the social consequences it produces. None of this requires a grasp of grand theories. In fact, attachment to such theories might seem to get in the way of pursuing the details. Following Foucault, we become skeptics of all metatheories.

DAVID HARVEY But maybe we have gone too far in this direction,
concentrating on the "how and where" to the
point where we forget entirely to ask "why."
We ignore the power of metatheory on principle
rather than as a convenient practice in certain
research situations. Whenever I ask somebody
who has been very deeply involved in a how-and-
where story:

> *Why did it happen?*

The answer nearly always comes back:

> *It's complicated.*

As if that in itself is an adequate answer.
My answer is:

> *Yes, I know it's complicated. But*
> *you've also got to tell me why. And*
> *if you can't do that because you*
> *are so totally wrapped up in the*
> *complications of the "how and*
> *where," then maybe you should*
> *rethink your research strategy.*

Exploring metatheories in relation to particular
instances might help us to ask deeper questions.
And those questions, thoughtfully pursued, may
lead to deeper understandings. I hope, in what
follows, to show how this might be so. (*Pause.*)
So why has all of that cement been spread around

DAVID HARVEY in China? Cement is used in construction. This
obviously suggests a massive investment in the
creation of built environments, in urbanization
and the construction of physical infrastructures.
Recently, there has been an immense amount of
that investment in construction worldwide. I've
seen evidence of it in almost every city that I have
visited in the last few years, but China stands out
in the data as by far the most spectacular
example. (*Pause*.) It is not only cement that is
involved in construction. There has also been an
enormous expansion of steel production and use
in China. In recent years, more than half of the
world's steel output and use has taken place in
China. A vast amount of iron ore is required to
make steel. Many other materials, like copper,
sand, and minerals of all sorts, are being
consumed worldwide at unprecedented rates.
In the last few years, China has been consuming
at least half (and in some instances 60 or 70
percent) of the world's key mineral resources.
(*Pause*.) Raw-material prices have, until recently,
tended to soar. Mining activity has been
accelerating everywhere. The terms of trade for
raw-material producers have tended to turn
positive in the last 20 years or so. From India to

DAVID HARVEY Latin America to Australia, whole mountains are
being moved in the search for minerals, with all
sorts of political, economic, and environmental
consequences. So the question of why China has
been involved in such a huge expansion of its
urbanization and infrastructural investment has
global ramifications. And it is undoubtedly one of
the reasons that a troubled global capitalism has
survived in the last few years. I am pretty sure
that the leadership in Beijing did not set out to
save global capitalism from a great depression,
but this is an effect of what happened—
particularly since 2008, when the global economy
went into a tailspin. (*Pause.*) To explain this,
I have to dig into the "how and where" of what
happened. (*Pause.*) In 2007–2008 there was a
financial crisis that originated in the United
States. Because it originated in the United States
it was defined as a global crisis. Other crises
occurred in Southeast Asia in 1997–1998 but
they were defined as regional crises. But in the
same way that the United States likes to call its
baseball championships a World Series, it likes to
refer to its crises as "world crises." And there is a
certain truth to this. The United States still has
one of the largest and most influential economies

DAVID HARVEY in the world. While it is no longer the case, as the
saying once had it, that if General Motors sneezes
the world catches cold, it is certainly the case
that major disruptions emanating from the United
States have far-reaching global consequences.
There is also considerable evidence that, faced
with crisis conditions, US institutions and policy
makers actively sought to disperse their effects
around the world by globalizing them. In so doing
they used many multilateral financial institutions
and financial interrelations to do their bidding.
(*Pause.*) The crisis of 2007–2008 was at first
instance quite localized. It originated particularly
in the southern and southwestern United States,
and arose largely out of intense speculation in
housing and property markets in those regions.
Speculative money poured into US property
markets (as it did in Ireland and Spain, among
other places) when the stock market crashed in
2001. The world was awash with surplus liquidity
at that time and much of it was absorbed in
property markets, forcing prices up and up. When
the speculative housing bubble burst, there was a
foreclosure crisis on housing loans. A "fictitious
demand" had been created when subprime
mortgage financing was offered to people who

DAVID HARVEY had very little credit worthiness. In 2007, property values collapsed in these regions and many people lost their homes. (*Pause.*) People who have been foreclosed upon and who are unemployed don't go out and buy things. So the consumer market in the United States collapsed and many people lost their jobs. But the primary supplier to that consumer market was China. This was one link whereby the local crisis went global. The other link was through the financial system. Financial institutions had structured mortgage debt on housing so as to be able to pass it on to others as an investment yielding good returns that were supposedly "as safe as houses." But many of the mortgages were not secured by an ability to pay. Anyone who had been gulled into investing in the new financial instruments lost money. The banks that held a serious part of the debt were threatened with failure and tightened credit, including credit to consumers everywhere. The weakness in the US consumer goods market spread and deepened. The downward spiral threatened to engulf the whole world in a depression. (*Pause.*) In 2008, China suddenly found its export industries contracting if not collapsing. A 20 percent or more

DAVID HARVEY drop in exports occurred in a matter of months. Chinese statistics are notoriously unreliable as to what is real and what is not, but by some accounts, something like 30 million jobs were lost in China through the collapse of export markets. This is a huge job loss. The Chinese government has traditionally been very nervous about potential social unrest. And 30 million unemployed workers presented a rather dangerous situation. I believe the Chinese government did what it did mainly to avert that obvious danger. (*Pause.*) By the end of 2009, a joint report from the International Monetary Fund and the International Labour Organization tallied up estimates of the global net job loss from the crisis. The United States had the largest loss, while China's net job loss was only about three million. Somehow, China had managed to absorb 27 million people back into the labor market in the space of about one year. This is an astounding and totally unprecedented performance. (*Pause.*) How did China absorb such vast amounts of surplus labor so fast? It seems the central government told everybody to create as many projects and megaprojects as possible. The banks were told to lend without restraint. In the United

DAVID HARVEY States, when the Federal Reserve and the US Treasury gave money to the banks to lend, the banks ignored their instruction. In the United States, the government does not have power over the banks. The banks used much of the money they were given to retire their bad debts and even buy back their own stock. The Chinese banking system does not work that way. In China, if bankers are told by the central government to lend, they lend. And they evidently did, incidentally making a lot of people ultrawealthy in the process. (*Pause.*) So China absorbed a massive amount of labor by launching a huge urbanization and infrastructure development program, building whole new cities, integrating the space economy of the nation with highways and high-speed rail networks, connecting southern and northern markets in a much stronger way, developing the interior so that it was much better linked to the coast. While clearly the central government had wanted to do something like this for some time (plans were laid for the high-speed rail network during the 1990s), it now mobilized everything it could to absorb the surplus and potentially restive labor force— probably because it thought it had to in order to

DAVID HARVEY survive politically. In 2007 there were zero miles of high-speed rail in China, but by 2015 there were nearly 12,000 miles linking all the major cities. This, by any standard, is a phenomenal performance. (*Pause.*) I am here reminded of what the United States did after World War II. The US economy needed to absorb the huge increase in productive capacity generated during the war and create well-paying jobs for a large number of returning veterans. If veterans were to be faced with unemployment on the scale of the 1930s, there would surely be serious political and economic consequences. The problem for the US capitalist state and class was:

> *How do we not go back into Depression? How do we absorb all of that productive capacity in ways that are going to be profitable and satisfy the wants and needs of a vast group of demobilized military? What would happen if the returning veterans faced a return to Depression conditions, when the war against Fascism had been fought in alliance with the Soviet Union?*

DAVID HARVEY One answer was the repression of all left-wing thinking through a fierce anticommunist movement known as McCarthyism. But McCarthyism could not have succeeded were it not for a number of initiatives that sought to solve economic problems. The US economy had to expand rapidly enough to absorb the surpluses of capital and labor. In part this was done through US imperialism, the Cold War (also anticommunist), and a vast expansion of militarism. These operations certainly played a role in boosting the economy, but were not enough to prevent another depression. The United States was a largely self-contained economy—not so dependent on foreign trade. Economic expansion had to be internal to the United States itself. (*Pause.*) The big thing accomplished after 1945 in the United States was a huge wave of investments in the built environment, in urbanization, and in physical and to some extent social infrastructures like the higher education system. The interstate highway system pulled together the West Coast and the South, and spatially integrated the US economy in new ways. Los Angeles was an ordinary-sized city in 1945, but by 1970 it had become a megalopolis.

DAVID HARVEY Metropolitan areas were totally reengineered with transport and highways and automobiles and suburbs and the development of a whole new suburban lifestyle (celebrated in popular TV sitcoms like *The Brady Bunch* and *I Love Lucy*). Well-paid jobs were required to support the effective demand for this suburban lifestyle. Labor and capital came to an uneasy compromise at the urging of the state apparatus in which a white working class made economic gains—while minorities were left out. As a result, the 1950s and 1960s were, in many respects, the golden years of capital accumulation in the United States: very high rates of growth, a satisfactory situation for a white working class, even as a powerful civil rights movement and uprisings in central cities showed that all was not well for the African American and immigrant populations. But the aggregate effect was to solve the overaccumulation problem through urbanization and investments in the built environment. As a Federal Reserve report later put it, the United States has the habit of "getting out of crises by building houses and filling them with things." My point is that this is also how capital gets into crises. (*Pause.*) In response to the employment

DAVID HARVEY crisis in 2008, the Chinese in effect did much the
same as the United States had done after World
War II, but they did it much more quickly and at a
far higher rate. This change of scale is very
important. I have come across this strategy of
using urbanization to solve economic and
political problems before. The economic crisis of
1848 prompted working-class and bourgeois
revolutions in Paris. Both failed and Napoleon
took absolute power in a coup d'état in 1852 and
declared himself emperor in 1854. Napoleon knew
that he would not last long unless he put labor
and capital back to work. A fan of the utopian
theories of Henri de Saint-Simon, he initiated a
lot of public works projects to be funded by
associated capital. To this end he brought Baron
Haussmann to Paris to rebuild the city. This was
one way in which surplus labor and surplus
capital were profitably absorbed. The French
economy flourished. Capital and labor were fully
and profitably employed in the creation of new
boulevards, department stores, and the like. Daily
life was transformed into the consumerism of the
City of Light. The crisis of overaccumulation of
both capital and labor in the period after 1848 was
solved by transformations in lifestyle as well as

DAVID HARVEY transformations in the built environment. We still
see the consequences of this effort when we walk
Haussmann's boulevards today. But the scale of
these changes is nowhere near that of the
changes in the United States after 1945, which in
turn is nowhere near the scale and speed of
transformation that has recently occurred in
China. (*Pause.*) But in each of these cases, there
was an underlying problem. The construction had
to be debt financed. New institutions and
methods of financing had to be created to sustain
building efforts. A new kind of credit-driven
banking became prominent in Paris. But at a
certain point, debt creation and skepticism as to
the value that stood behind the debt came to the
fore. Paris's debt crisis of 1867–1868 engulfed not
only the speculative financial institutions but
also the finances of the city. Paris was mired in
debt and close to bankruptcy. Haussmann
was ultimately forced to resign. (*Pause.*)
Unemployment and unrest ensued in Paris.
Napoleon III sought to save himself with a
nationalist strategy that led into the Franco-
Prussian War of 1870–1871. He lost the war and
fled to England. In the wake of the war and the
German siege of Paris the inhabitants made their

DAVID HARVEY own revolution—the Paris Commune of 1871—
one of the greatest urban uprisings in human
history. The people took back "their" city from
the bourgeoisie and the capitalists who
had plundered it. (*Pause.*) Solving the
overaccumulation problem through rapid
urbanization comes at a certain cost. In the cases
of both Paris and the United States, it meant
relying heavily upon debt finance and the
deployment of fictitious capitals. In the United
States, new mortgage finance and other
institutions had been put in place in the 1930s, but
even greater levels of state intervention occurred
after 1945. The system worked well for a time,
but stresses were evident as early as 1967. The
whole process came to a crashing halt with the
property market collapse and the technical
bankruptcy of New York City in 1973–1975 (one of
the largest public budgets in the capitalist world
at that time). This initiated a period of serious
recession and capitalist restructuring in the
United States that also affected the United
Kingdom, Europe, and the rest of North America,
as well as many other countries and regions such
as Australia and Latin America. In a somewhat
similar fashion, the crash of the US stock market

DAVID HARVEY in 2001 led money to flee the stock market and
produced the property market boom that helped
sustain global capitalism up until the Lehman
Brothers collapse of 2008. And the impact of the
Lehman Brothers collapse was felt throughout
the global financial system. (*Pause.*) China
likewise debt financed its way out of its
difficulties in 2008. But unlike Greece and other
places, China didn't debt finance using dollars or
euros. It had enough foreign exchange surplus
from the United States to be insulated from
foreign pressures. So China could borrow in its
own currency. The great advantage of borrowing
in your own currency is that you can always issue
more money and if necessary inflate away the
debt and recapitalize the banking system (as
happened at the end of the 1990s). By 2015, China
had moved from a fairly low debt-to-GDP ratio to
one of the highest in the world. A hidden banking
system came into being to cover over many of
the gaps in finance and hide a lot of the debt
obligations. China doubled its debt-to-GDP ratio
in about six years through huge urbanization and
infrastructural investment surges. Reports
circulated suggesting many municipal and local
governments were effectively bankrupt by 2013

DAVID HARVEY and the condition of some lending institutions
was dire. Nevertheless, about a quarter of the
Chinese GDP was taken up by housing
construction alone, and when all of the other
investments in the built environment were added
in, it turned out that about half of Chinese
economic activity and growth was arising out of
reshaping the built environment—hence all that
production and consumption of cement and steel.
China, like the United States before it, was
avoiding recession and a potential depression
along with the political threat of widespread
unemployment by "building houses and filling
them with things." (*Pause.*) This was the Chinese
answer to what might have been a very serious
depression in 2008. This answer, however, was not
unique to China. There were attempts to emulate
it elsewhere. Turkey, for example, which went
through a crisis in 2001, got out of the problems of
2007–2008 through the same kind of expansion in
its urbanization: a new airport, a third bridge over
the Bosporus, the urbanization of the northern
part of the Bosporus to create a city of some 45
million people. Every city in Turkey showed
evidence of a building boom. Largely as a result
of this boom, Turkey was hardly affected by the

DAVID HARVEY crash of 2008 (although it, too, saw its export industries suffer). Turkey had the second highest growth rate after China in the post-2008 period. Spectacular urbanization in the Gulf states also absorbed a lot of surplus capital. In major urban centers, property markets quickly revived for the upper income brackets after 2009. New York City and London soon were experiencing property revivals in high-end construction even in the absence of any investment in affordable housing for the less well off. (*Pause.*) Anybody who supplied China with the necessary raw materials, like copper or iron ore, came out of the crisis of 2008 pretty well. Most of Latin America, which was full of raw materials, recovered relatively quickly. In addition, Latin America turned itself into one vast soybean plantation, basically, for Chinese trade. It switched its allegiances in terms of global trade to the Pacific and to Asia. The depression, which affected the United States and elsewhere, didn't really affect Latin America to the same degree. It was relatively mild. Mineral-rich Australia likewise thrived. (*Pause.*) Brazil, besides having raw materials, did the same thing the Chinese had done. When the crisis hit, President Lula said:

DAVID HARVEY *We're going to build a million*
 houses—low-income houses
 for the poor.

That program, Mi Casa Mi Vida, became part
of the Brazilian answer to what was a rather
shallow depression in 2007–2008. Unfortunately,
as often happens, the Brazilians basically
gave money to construction companies but
didn't ask them to urbanize in any sensible way.
So the construction companies built shoddy
housing in bad environments without any kind
of infrastructure. They didn't build a city. They
didn't build livable urbanization. They just built
houses and dumped them down wherever they
could find a place to put them. Of course that
absorbed capital and labor. But it didn't create a
decent living environment for anybody. (*Pause.*)
When we step back and look at the world in
aggregate during this period, a strange dichotomy
becomes apparent. There is this vast urban and
infrastructural expansion going on in China,
with outliers in other countries (like Turkey) or in
other sectors (like high-end condo construction
for the rich in major urban centers around the
world). These strategies enabled many countries
to recover quickly from the effects of the crisis

DAVID HARVEY of 2007–2008. In the United States and Europe,
however, we find a commitment to the politics of
austerity, which locked their economies into no
growth. In these parts of the world, the politics
of neoliberal orthodoxy and austerity were—
largely for ideological reasons—tightened. So
the world effectively divided into two camps: the
Chinese expanded through broadly Keynesian
practices, which depended upon demand creation
led by the state; the West, on the other hand,
contracted through its dedication to supply-side
management that focused on fiscal practices
of debt reduction. Public policies and politics
were shaped accordingly. The Chinese camp
effectively rescued capitalism from a threat of
deep depression through massive urbanization
and investment in infrastructure. (*Pause.*) But
as happened to Haussmann in 1867, and as
happened to the grand suburbanization spree at
the end of the 1960s in the United States, all good
things come to an end. In the years since 2013,
China has been increasingly exhibiting signs that
its solution is running out of steam, that there is
chronic overproduction and overaccumulation
in the built environment, that its economy
is burdened by vast holdings of nonearning

DAVID HARVEY assets, and that the returns from the undoubted
improvements in productivity are just not there.
It may no longer be possible to continue down
the path of endless expansion of investments
in housing and other physical infrastructures.
(*Pause.*) Ventures of this sort elsewhere have also
run into difficulties. Dubai World went bankrupt
and had to be bailed out. The Turkish boom has
been cut short; foreign investors are bailing
out and empty apartment blocks litter the land.
(*Pause.*) It is simply not possible to continue such
strategies forever, and the volatility in fortunes
is marked. As the construction boom recedes,
surplus productive capacity in, for example,
cement and steel production, becomes a problem.
The global demand for raw materials slackens
and the terms of trade for raw-material producers
turn unfavorable. Two or three years ago, Brazil
was flush with money. Now it is in recession.
The money has dried up. Politically everything
is also falling apart. Since 2014 most of Latin
America has seen deepening economic distress.
And a substantial part of the reason is that the
Chinese market is not so vigorous anymore.
The slackening of demand from China has had
negative effects elsewhere. Even Germany, which

DAVID HARVEY exports high-tech machine tools and equipment
to China, has felt the drought. (*Pause*.) In this way,
the crisis tendencies of capital have been moving
around. This is where macrotheory proves helpful.
It helps us understand why crisis tendencies
necessarily move around geographically from
one part of the world to another, and sectorially
from one industry to another. A housing crisis in
the American South and West creates a financial
crisis in New York and London, which becomes a
credit crunch across Europe and North America,
which is solved by the proliferation of sovereign
debt crises, which produce cascading crises in
the living standards of the people. At the end of
the day it is the people who pay and the people
who suffer while capital is rescued. Just look at
Greece. (*Pause*.) As crises move around, they
are subject to interpretation by the media and by
popular commonsense explanations as having
different causalities. In the Greek crisis, the
fight with the Germans occurred because many
Germans believed the Greeks were lazy and
culturally backward. Very simplistic explanations
circulate, like:

The crisis is due to immigrants . . .

DAVID HARVEY (very common theme in Europe and the United
States), or:

> Lazy welfare cheats and unfair
> foreign competition . . .

(from China!). Scapegoat and blame everyone
and everything, except capital! (*Pause.*) My thesis
is that not only do crises get moved around, but
crises are embedded in the very structures of
what capital accumulation is about. My thinking
here is guided in part by a reconsideration of
Marx's theory of value. Marx is interested not only
in value, but in anti-value. The idea of anti-value
is simple. A capitalist invests in producing a
commodity and the commodity has a potential
value. But if nobody wants, needs, or desires the
commodity, then it has no value. The history of
capital is, therefore, about the production of
new wants, needs, and desires. And this is what
the transformation of Paris and the building
of the suburbs in the United States entailed.
And it is what's happening so dramatically
in contemporary China. The cultural and
psychological jump from peasant life in a village
without any mobility to whizzing around the
country in high-speed trains is huge. Without
this, what seemed like socially necessary labor-

DAVID HARVEY time becomes socially unnecessary labor-time.
A theory of devaluation of capital as an answer to
overaccumulation also derives from this. Surplus
capital and labor may be absorbed by investments
in infrastructures and the built environment but
the result is often the creation of excess
productive capacity. The result is devaluation.
This is the problem that is haunting China right
now. Anti-value is everywhere. If it cannot be
redeemed by new value production, the result is
devaluation. (*Pause.*) I am struck here by a
powerful analogy. Physicists explain the birth of
the universe in terms of the clash of matter and
anti-matter. Marx explains the dynamics of
capitalism in terms of the relationalities of value
and anti-value. This also may be what Joseph
Schumpeter meant by the term "creative
destruction" as an essential feature of
capitalism. (*Pause.*) Capital systematically
creates anti-value in the form of debt that can
be redeemed only through future value
production. This aspect of Marx's theory has not
been looked at closely enough. Anti-value is
fundamental to value. You cannot do without it.
Recent events illustrate the relations involved.
The crisis of 2007–2008, for example, had its roots

DAVID HARVEY in the way that the earlier crisis of 2001, which
was focused on the US stock market, was
resolved. When the dot-com economy crashed,
money rushed out of the stock markets. The world
was awash with surplus liquidity (as the IMF
repeatedly complained). But where was this
money to go? Alan Greenspan, head of the
Federal Reserve, dropped the interest rates.
Property investments looked attractive. Money
was lent to producers of housing at the same time
that it was lent to consumers, on easy terms.
Finance supported both the supply and, even
more importantly, the burgeoning demand for
housing. Prices of property assets rose rapidly.
Investing in property looked even more attractive.
But debt requires the creation of value to redeem
it. If this new value does not materialize, then you
go bust. In this way, credit and debt dictate future
value production. Either that or devaluation or
even destruction of capital ensues. (*Pause.*) This
disciplining effect of debt encumbrance is
important. Debt means we are no longer "free to
choose," as Milton Friedman in his paean to
capitalism supposes. Capital does not forgive
us our debts, as the Bible asks, but insists we
redeem them through future value production.

DAVID HARVEY The future is already foretold and foreclosed (ask any student who has $100,000 in student loans to pay). Debt imprisons us within certain structures of future value production. (*Pause.*) This was well understood back in the 1930s when all of those reforms occurred in the US home-mortgage market. The prize of home ownership could be achieved by resorting to the 30-year mortgage. And debt-encumbered homeowners don't go on strike, it was said. So after World War II, the strategy was to debt encumber as many homeowners as possible. They then would have to support the capitalist system in order to pay off their debts. These homeowners would live in the suburbs, out where revolution was hardly going to be on the agenda. They would have to have cars and lawn mowers, and would increasingly aspire to nice homes and swimming pools. (*Pause.*) Suburbanization contributed enormously to social stability and fostered certain mental conceptions of the world and political subjectivities to support rather than challenge the status quo of a rampant capitalism. The World Bank and the IMF promote individual home ownership worldwide because, they say, it assures social stability. But this does not solve

DAVID HARVEY the overaccumulation problem, which has
produced the foreclosure wave, which has in turn
destabilized whole populations and communities.
Foreclosed homeowners and people who feel
threatened by increasing insecurities are
unsurprisingly doing all kinds of crazy things
politically, both on the left and on the right—
hence Donald Trump and the Tea Party and Bernie
Sanders and his quest for a political revolution.
What has traditionally been a solution becomes
the problem. Saddling whole populations with
massive debts they cannot possibly repay—as in
the case of Greece and to some extent the case
of student debt in the United States—is a
contradictory recipe for social stability. (*Pause.*)
I lived in Baltimore for many years. When protests
broke out there in 2015, I was reminded of what
happened back in 1968, just after Martin
Luther King, Jr. was assasinated. Baltimore
burned. Many years later there was a repeat
performance. In between lie three decades
of deindustrialization and a decade of subprime
lending in the housing market primarily for
African Americans and single-headed
households. The foreclosure wave recreated
social instability with asset-value losses

DAVID HARVEY concentrated in marginalized minority populations. The difficulty is to figure out a response that avoids the obvious risk of repeating such disasters. (*Pause.*) This then raises an interesting question as to what options exist for China. What are the Chinese going to do, given their grumbling overcapacity? Here the idea of the "spatial fix" is useful. When there are surpluses of capital and labor in a particular territory, and when prospects for profitable use are negligible because the market is saturated, then capitalists start to export their surplus capital (and sometimes surplus labor) to build elsewhere. This was what economic imperialism was about from the mid-19th century onward. Surplus capital and labor from Britain came to the United States or went to Australia, South Africa, and Argentina. But where did these places get their money to buy up the surplus capital in commodity form? Surplus money capital was lent to those countries so they could build their railroads and infrastructures, which created a demand for British surplus capacity in steel and locomotive production. This ultimately led to the creation of new and dynamic capitalist economies elsewhere, particularly in the United

DAVID HARVEY States. This was the creative economic side of British imperialism. (*Pause.*) The other strategy was more negative. Britain tried, for example, to keep India as a captive market to which they could send their surplus product after destroying indigenous productive capacity. But this did not help resolve Britain's problems of overaccumulation of capital and surplus labor because the demand from India was not very strong or expansive over time. Indians were therefore forced to produce all kinds of things— including opium to sell to China in return for silver, which was then shipped back to Britain. Britain drained wealth from India and China but did not help create much wealth. This was a nondynamic form of imperialism. (*Pause.*) Britain could not suppress industrial development in the United States the way it had done in India. The surplus capital and labor that came from Britain to the United States helped create a new and expansive center of capitalist development. This created an ever-increasing demand, which could absorb British goods—a much better solution to Britain's overaccumulation problems than the exploitation of Indian wealth ever was. The only problem was that at some point the United States

DAVID HARVEY became a stronger, larger, and more competitive economy than Britain. The United States then began to generate surplus capital, and in turn had to figure out what to do with it. So it too began to export capital and to develop imperialist style practices. (*Pause.*) This process of creating spatial fixes to deal with the tendency toward overaccumulation is apparent everywhere. The Japanese turned toward the export of surplus capital at the end of the 1960s; South Korea followed suit in the late 1970s; and Taiwan in the early 1980s. Flows of surplus capital from these territories went all over the world but were particularly important in building productive capacity in China. Now it is China's turn. (*Pause.*) China has a lot of overcapacity in sectors such as cement and steel production. How is this overcapacity to be absorbed? The state is attempting to reduce capacity in these sectors a bit through plant closures. But China is also looking for opportunities to spread this surplus cement and steel around. This is what is scary. They have come up with a number of answers. One of them is internal. The Chinese are proposing to create a city of something like 130 million people—equivalent to the population

DAVID HARVEY of the United Kingdom and France combined. It will be centered in Beijing. Investments will be focused on high-speed transport and communications. This new city will absorb a lot of steel and concrete. But what kind of daily life would be possible in such a city? In fact what is being proposed is not a city in the conventional sense. It is the rationalization of not one but three major urban regions: one centered in Beijing, the second in Shanghai, and the third in Guangdong Province. Several multimillion-inhabitant cities already exist in each of these regions. The plan seems to be to seek a higher-order rationalization of relations between these rapidly expanding cities so that they knit together more efficiently. Planners will doubtlessly mine large data sets on, for example, existing movement patterns, and put the concept of "smart cities" into overdrive in the cause of this hyper-rationalization of space relations. These rationalizations will surely entail the use of surplus cement and steel. (*Pause.*) But that will not be enough to absorb all the surplus capacity. China is attempting to dispose of its surplus cement and steel by exporting as much as it can at low cost. This means that higher-cost steel plants elsewhere (in Britain, for example)

DAVID HARVEY are being forced to close. China is being
challenged by the United States and others
before the World Trade Organization for dumping
subsidized steel in the world market and may
be obliged to stop this trade. But Chinese
corporations are also building railroads,
highways, and physical infrastructures in East
Africa using Chinese cement and steel as
well as surplus Chinese labor, even though there
is plenty of local surplus labor. The same is
happening in Latin America. Proposals exist to
build a competitor to the Panama Canal through
Nicaragua, and transcontinental rail lines running
from the Pacific to the Atlantic coasts. We will be
able to get from the port in Lima to São Paulo in
about a day and a half. Several proposals of this
kind were laid out some time ago, but nobody took
them seriously until the Chinese came along and
said they had plenty of cement and steel and that
they would lend the money to purchase these
materials and to build the infrastructures.
(*Pause.*) Other business press reports show
how China is rebuilding the Silk Road route from
Shanghai to Istanbul (and into Europe) via Tehran.
A fast, high-capacity rail network (using a lot of
cement and steel) is planned through Central

DAVID HARVEY Asia into Europe. Central Asian cities along the
route are already experiencing building booms.
This is a program that would probably not occur
were it not for the fact that the Chinese have all
of this surplus capacity in cement and steel
production. This is one of the ways in which
they hope to stabilize what might otherwise
be a "rough landing" in a Chinese economy
suffering from overcapacity. The surplus capital
overaccumulation problem can be resolved, for a
time, by resorting to a spatial fix. (*Pause.*) This
has happened many times before—but there is
something different this time around. If you look
at the scale of Haussmann's project in Paris, it
was about the city. If you look at what went on
in the United States after World War II, it was at
the level of the metropolitan region across the
whole nation. Robert Moses was the iconic figure.
You move from Haussmann to Moses, from city to
nation. But the figures of China's cement use are
indicative of another dramatic change of scale
that appears global in reach. And it is of an
enormity that I find deeply troubling. (*Pause.*)
At this point we should step back and ask:

Why this dramatic change of scale?
Is this really necessary? Why does

DAVID HARVEY

it seem so inevitable? Why is it that it seems so impossible to say, "no, no, we don't want that"? Why can't we make something different? If capital is about freedom of choice, why is it that this future is foretold?

The answers have a lot to do with the nature of capital accumulation. Capital accumulation is, of course, about expansion. About growth. And for a very simple reason. The capitalist starts the day with a certain amount of money, goes into the market, buys labor power and means of production, creates a commodity, and sells it at the end of the day. Value has to increase. In a healthy capitalist economy, all capitalists possess more value at the end of the day than they had at the beginning. (*Pause.*) So when we look at the history of capital accumulation, we see that it has been growing at a compound rate. Compound growth rates produce exponential curves. And exponential curves dawdle along and then suddenly take off and sweep upward at an alarming rate. There is an inflection point in exponential curves where the upward sweep starts. It's like the famous story of the person who invented chess and asked the king to give

DAVID HARVEY him a reward. He asked the king to put one
grain of rice on the first square and double it
for every square. By the time you get to about
the 46th square, all the rice in the world is used
up. And how you get to the 64th square, nobody
knows. (*Pause.*) This is the nature of compound
growth. (*Pause.*) Compound growth is built into
the capitalist accumulation process. But there
is, alas, no law to stop it. All of us tend to get
involved in urbanization projects organized
around the question of how best to make things
grow. We want growth. But why do we want
growth? Why in particular do we want compound
growth when we know it will likely spiral out
of control and become impossible? (*Pause.*)
Limitless growth is the wrong thing right now.
We're on that inflection point on the curve of
global accumulation. And if we actually double
or triple the amount of cement we have to pour in
30 years time, which is implicit in what compound
growth is about, our grandchildren will be up to
their ears in cement. This is not a feasible project.
Right now, the problems of the environment are
serious enough to say we have to do something
about this absolutely senseless commitment to
growth come what may. (*Pause.*) And there's an

DAVID HARVEY irony here. Actually, in Europe and the United States, we've seen very slow growth in recent times—for all the wrong reasons. But at least it's environmentally friendly. The places that have not seen slow growth have experienced great environmental stress. This has spilled over to wherever surplus capital moves. More than half of foreign investment in Ecuador is Chinese. When oil prices collapsed, Ecuador had to borrow from China. They borrowed to build things like a huge hydroelectric project that will provide almost half of the country's electricity. And of course, Ecuador also wants to support putting a highway over the Andes. These megaprojects are being built with Chinese steel and cement. They are happening because of the necessity for endless growth of capitalist accumulation. (*Pause.*) We have to think about how to organize an economy in a way that is not dedicated solely to economic growth. There are hints of this in many places. Ecuadorians and others have enshrined the objective of Buen Vivir into their constitutions. The UN Human Development Reports try to separate economic growth from the development of human capacities and powers and seem to focus policies on the latter. There are all sorts of

DAVID HARVEY initiatives to promote social entrepreneurialism and the sharing economy in conventional circles, and more far-reaching pushes on the left to foster cooperatives and solidarity economies.

In practice, most of these initiatives turn out to be either mere rhetoric or masks for the continuation of capital accumulation by other means. There is widespread recognition of the need to reorganize and reorchestrate the use of the world's resources. But here too the realities are vastly different from the rhetoric. Ecuador enshrines the indigenous idea of the rights of Mother Nature into its constitution. But as China pursues its own spatial-fix spending spree on a global basis, it needs, as we have seen, a lot of mineral resources. So when Ecuador borrows from China, in return, the Chinese want open access to all the mineral resources of southern Ecuador, which happen to be where a lot of indigenous populations are. And those indigenous populations are not liking what's happening. A political struggle ensues. Indigenous leaders are being killed. This is an all-too-familiar story. You have heard it often in the past and you will hear more of it in due course. (*Pause.*) This is what compound growth is all about. We need to

DAVID HARVEY find ways to manage and eventually contain it.
Within the urban process, something else
is going on that requires careful attention.
Urban growth is increasingly about creating
possibilities for investment of surplus capital and
surplus savings. It is only incidentally, if at all,
about creating a decent urban life. I mentioned
the Brazilian case because it was about
feeding construction interests and employing
surplus labor and capital in construction. But
construction of what? There was no commitment
to creating decent urban environments. It was
simply about absorbing surplus capital and labor.
But the urban property market has also become
a market for investors of surplus savings. It
seems that we are less and less interested in
creating cities for people to live in. Instead, we
are creating cities for people to invest in. (*Pause.*)
Why is this? And why do I see it even in Palestine
and Turkey, as well as in New York, London,
Shanghai, and all the other major cities I have
visited recently? It arises because people have
surplus money, which they are looking to invest
and save for their futures and for their families'
futures—this is where individualism and private
property relations come in. So people are asking:

DAVID HARVEY

Where do I put my savings in these times? Where is a safe place? Do I put it in the stock market? Do I keep it in monetary instruments of some kind—bonds?—now earning zero percent or even negative rates of interest? Or do I put it into the purchase of property assets?

A lot of capital has been flying into this last option since the 1970s. That trend seems to be accelerating as other options either offer very low rates of return or appear, like the stock market, to be increasingly volatile and high risk. (*Pause.*) The housing market and property market went through a crash in 2007–2008 in many parts of the world after nearly a decade of speculative activity. But guess what? One of the primary objectives of people right now is to invest in property and land because this seems a safer choice to preserve and enhance value in a generally weak and insecure investment climate. Land and property are now much more favored as destinations for absorbing surplus liquidity and protecting savings. (*Pause.*) I've seen this both in Turkey and in Palestine. Around Ramallah, they're building these high-rise apartment blocks.

DAVID HARVEY Who is building them? Well, it's some of the
people who work in the Palestinian Authority,
which is notoriously corrupt. And those people
are taking their money, and they're putting it
into property and land because they offer some
security. (*Pause.*) Recently, China has loosened
its regulations over export of private capital.
Some of the primary buyers of property in New
York right now are private Chinese investors who
are getting their money out of the country one
way or another and buying property elsewhere.
During the Irish boom a lot of investment came
from Ireland into the New York property market.
And, like the Chinese in London, the Russians,
the Saudis, the Australians are doing the same.
And it's not only the billionaires who are doing it.
It's actually upper-middle-class people who are
engaging in the equivalent of a property and land
grab wherever they can. Likewise, most pension
funds are increasingly investing in this direction.
My own pension fund, TIAA-CREF, is doing
this, and stirring up some controversy. They are
involved in some pretty ghastly things in Latin
America in terms of land grabs. (*Pause.*) Since
2008 we have been seeing a redirection of capital
flow away from creating livable environments

DAVID HARVEY for the masses toward creating investment opportunities for individuals who want to store their money and keep their wealth in some form that they feel is fairly safe. Property markets are becoming a target also for hedge funds, which are buying up foreclosed houses and speculating on a revival of values. Of course, if you had tried this in Syria, you would have lost out very badly. But in other parts of the world, land and property are judged still to be a primary form of secure and safe investment. The financiers and developers oblige by building upscale investment properties in situations where there is a crying need for affordable housing for the mass of the population. (*Pause.*) This raises the question:

What should planners be doing? Should they be spending their time trying to figure out how to create investment opportunities for middle- and upper-class people? Or should they be seeking to create an alternative urbanization that responds to what the mass of the people need, want, and desire? (*Pause.*) There is, I sense, tremendous alienation right now in terms of what the urban process is about. It is therefore no surprise that over the last 15 years or so some of the major outbreaks of discontent in

DAVID HARVEY the world have had an urban base. Gezi Park—
what was that about? It wasn't a working-class
uprising. This was a cultural and popular uprising
against the diminished and degraded qualities of
urban life, the authoritarianism, and the lack of
democracy in the city's decision-making
processes. The recent crazy course of politics in
the United States has a lot to do with the impact
of the foreclosure crisis and a spiraling sense
of anger and anguish within the population as a
whole that nothing can be done about the
declining qualities of urban services and urban
life. (*Pause.*) Through the foreclosure crisis many
people lost their houses—their primary form of
savings, their financial security. They are angry
about their dispossession. They need somebody
to blame. They can't blame capital because
everybody tells them that would be a socialist or
even communist position to hold. But the great
thing about Bernie Sanders is that he's actually
made socialism partially respectable, particularly
with people under 35. He says we should do away
with student debt, and that higher education
and health care should be free and open to all.
Such ideas sound pretty good to the younger
generation. If that is socialism, why not? (*Pause.*)

DAVID HARVEY But it is at this point where we have to think more
carefully about the "why." In essence, the "why"
is very simple. Accumulation for accumulation's
sake, as Marx points out, is the center of what
capital is about. And that translates to production
for production's sake—which either means
pouring more and more cement everywhere until
we are up to our necks in the stuff, or saying
we have had enough of this and need to do
something different. We should at least consider
getting off the capitalist treadmill of limitless and
endless accumulation and think about ways to
organize our economy along totally different lines.
(*Pause.*) I am a great admirer of many of the
things that capital has created. And Marx was
too. We have a lot of wonderful things we can use
in a completely different way if we put our minds
to it. But in order to do so, we have to get out of
the ideological mess that we've gotten ourselves
into, which says there are certain things that
can be said and studied and certain things that
cannot be said and studied. The boundaries
between acceptable and unacceptable research
and thinking are as firmly fixed in universities as
they are anywhere else. Anticapitalism is not by
and large considered an acceptable perspective

DAVID HARVEY from which to work. Yet it is the only perspective
that makes real sense for these times. (*Pause.*)
And that is one of the more horrific things
about our current situation. The problems and
processes I am describing are not debated
and discussed in the way they should be
debated and discussed in the institutions that
should be discussing them. Universities in the
United States and elsewhere have been
corporatized. They have become neoliberalized.
They have become bastions of knowledge
dedicated to the perpetuation of endless capital
accumulation, capitalist growth without limits,
even as they channel innovation into supposedly
solving the problems of, for example, social
inequality and environmental degradation.
(*Pause.*) There is some resistance, of course.
Universities are to some degree still open and
they will probably always be hard to tie down. But
the resistance is weak because money power
increasingly lies on one side of this struggle as
universities face public funding cuts in favor of
private and corporate support or debt-financed
tuitions. Debt-encumbered students tend not to
rock the boat. That trend is becoming stronger
and stronger. It could be reversed, of course, but

DAVID HARVEY at this time the political prospects for such a shift are rather bleak. (*Pause.*) At the same time, the political base for radical movements and social change has also shifted. Contemporary discontents in many parts of the world now emanate from a rather different class configuration from that which the left has traditionally favored. This question of class configuration to political struggle must be approached from a different direction. These reconfigurations have much to do with the paths of contemporary urbanization. I find myself at this point somewhat at loggerheads with much of the traditional Marxist fraternity. (*Pause.*) Marx put a great deal of emphasis on the production of value and surplus value through the exploitation of living labor in the labor process. *Volume 1* of *Capital* focuses exclusively on this. *Volume 2* is about circulation of capital as a whole, with particular emphasis on the realization of value and surplus value in the market. Just to complete the picture, *Volume 3* is about the distribution of value and surplus value—a topic that is assumed away in the other two volumes apart from the obvious distribution relation between the wages of labor and the profit (surplus value) that accrues

DAVID HARVEY to capital. Marx is very clear, in *Grundrisse* and elsewhere, that in order to understand capital, you have to understand what he called the contradictory unity between production and realization. (*Pause.*) *Volume 1* is read in Marxist circles and revered, quite rightly, because it is a magnificent book. *Volume 2* is hardly read at all because it is not only incomplete, but also very dry—and some of it is basically unreadable. But if you don't study it, you don't understand how capital circulates. And unfortunately a lot of Marxist thinkers have not understood capital because they have ignored *Volume 2*. (*Pause.*) At the end of the first section of *Volume 1*, chapter 1, Marx tells us that the potential value created in production comes to nothing if it is not realized through a sale in the market. This is where anti-value comes in. And that means we need to study very carefully the processes of realization. For most of *Volume 1*, Marx assumes that all commodities exchange at their value, which means that there are no problems of realization. This is not a realistic assumption though it is understandable that Marx might appeal to it to study other aspects of capital accumulation. In practice, the realization of values under

DAVID HARVEY conditions of accumulation rests upon the production of new wants, needs, and desires backed by ability to pay. The politics of the production of such wants, needs, and desires has been a tortured and intriguing history beset with all manner of social struggles that have often passed by unobserved and unremarked. But without them capital would have collapsed long ago. This then poses the problem of how to imagine a world of perpetually escalating wants, needs, and desires frequently not backed by an ability to pay (except through escalating personal and corporate debt) and in any case cast in such a way that they cannot be satisfied or fulfilled because if they were, that would mean the end of further capital accumulation. The production of unsatisfied and in some instances unsatisfiable needs is fundamental. We have already encountered a major example of this in the production of suburbanization as a new way of life for the mass of the population in the United States after 1945 and how this rescued global capitalism from collapse. (Pause.) Furthermore, as we have seen, capital can extract wealth as much from the realization process as from the production process. The worker may earn more,

DAVID HARVEY but is no better off if he or she goes home and
pays higher rents and inflated living costs
imposed by price-gouging merchants and service
providers. What workers may gain in the form
of higher wages through work-based struggles
may be recuperated by capital at the point of
realization. (*Pause.*) If you ask people what the
major forms of exploitation experienced in the
United States are today, they mention credit card
fees. They mention landlords and rents and
property speculators. They mention what
telephone companies do to their telephone bills
by adding all these weird charges that say you
were roaming someplace where you weren't. They
mention health insurance companies, local taxes,
transport costs, and so on. There is an immense
amount of racketeering (sometimes akin to
robbery) that goes on at the point of realization.
The politics of struggles over realization are
apparent everywhere. (*Pause.*) It is also important
to recognize that realization of value does not
necessarily occur at the same geographical
space as production of value. My computer
contains value produced in China by Foxconn, but
its value was realized in the United States by
Apple. The bulk of the value is realized by Apple

DAVID HARVEY (or Wal-Mart or the Gap), when most of value is created by direct producers in China. Merchant capitalists realize much of the value that is created by the activities of industrial capital elsewhere. (*Pause.*) A lot of wealth is being extracted from the realization process. And a lot of that wealth extraction occurs in the course of daily life on the streets of the city. It is therefore no accident that most of the uprisings we have seen in recent times, such as those in Brazil and in Turkey in 2013, were more about the politics of realization than they were about the politics of production. Discontent with the qualities of urban life have brooked large in such struggles. This is where a lot of contemporary politics now lie. We need to pay attention to it both theoretically and practically as well as politically. But to understand that, we need to undertake a careful study of *Volume 2* and *Volume 3* of *Capital* and not remain content with a reading of *Volume 1*. (*Pause.*) Realization struggles are difficult to theorize and organize for a number of reasons. First, the class configuration that's involved in the extraction of wealth through realization is different from that which is involved in production. It's not capital versus labor in

DAVID HARVEY the realization process. It's capital versus
everybody else affected by the thievery and
racketeering that goes on. The struggle is
between buyers and sellers rather than between
labor and capital. Upper-middle-class populations
are buyers and get involved in struggles
(sometimes of the not-in-my-backyard sort)
against racketeering merchants. Do we seek
them out as allies against the property
speculators? (*Pause.*) Go to a small family
restaurant in New York City and ask the
owners why they pay their workers so badly.
The immediate response would be:

> *You don't understand. I'm exploiting
> myself at a huge rate. I get in here at
> six in the morning. I don't go home
> till ten at night. I work my ass off.
> How can I afford to pay anybody
> much more than I get?*

Then ask:

> *Where does all the money you
> make go?*

The answer is:

> *To the bank to pay interest on the
> loan, to the landlord to pay the rent,
> to the electricity company to pay*

DAVID HARVEY *the bill, and to the taxman of course!*
 And by the way, the landlord raised
 the rent by 25 percent just last year
 and there was nothing I could do
 about it.

A lot of family businesses are closing down
because of rapidly rising rents in New York City.
So if I said to that person:

Hey, let's form an alliance against
the banks and the landlords and
the taxman.

I think the answer would be:

Yes, that sounds a great idea.

But this is rather far from the conventional
vision of a proletariat as a primary agent
of political change. (*Pause.*) These are the
sorts of frustrations that can produce political
movements to the right as well as to the left.
But the deep and complicated discontents
with the qualities of daily urban life need to
be addressed. We should not dismiss them as
secondary. (*Pause.*) We've got to understand why
and how the discontents with daily life in the
city are escalating, and why and how they might
be reconfigured around a political movement
dedicated to the idea that we need and want

DAVID HARVEY to create cities that are fit for people to live in. In practice, as we have seen, we are more likely to be creating cities that are fit for people to invest in. (*Pause.*) This has to be reversed. We want not only to create cities that are about nongrowth, but cities that address social needs, reduce inequalities, and improve environmental qualities. (*Pause.*) Marx deploys an interesting idea, which comes from Hegel. Hegel talked about the difference between what he called a "bad infinity" and a "good infinity." A good infinity is something that continues to reproduce itself over time forever. A circle is a mathematical depiction of the good infinity. (*Pause.*) It's when the circle becomes a spiral that problems start. Things spiral out of control. Capital is spiraling out of control. And that spiraling out of control is represented by the fact that the infinity is not contained in any way. It just goes further and further and further. The number system is a bad infinity. For every big number you can make, there's always one more you can add to it. It goes on and on and on and there is no telling where it will go because it will never come to a close. It's like pi in the other direction. How many decimal places do you write for pi? (*Pause.*) We have to

AUDIENCE *[APPLAUSE]*

AUDIENCE Thank you. I agree that it's important to
 emphasize this notion of capital realization by
 Marx. I also feel that there is a parallel between
 this and what Karl Polanyi talks about as market

DAVID HARVEY get back to a good infinity. Marx understood that very well. He is very strong about the nature of reproduction—reproduction of the social order and how we can think about reproduction. In both *Volume 1* and *Volume 2* of *Capital* he describes in detail the virtuous infinity of simple reproduction. It is with reproduction on an expanded scale that the problems really start. The metaphor of spiraling out of control is something that is very meaningful to what is happening globally and locally. Until we can find means to control endless accumulation for accumulation's sake, there is no amount of tinkering and doing good things on the edges that will make much of a difference to a huge macroeconomic problem. (*Pause.*) This is why the anti-capitalist perspective is so crucial to defining the nature of the problem of contemporary urbanization. (*Pause.*) Thank you. (*Pause.*) I can take a few questions.

AUDIENCE forces and market society—this notion that the really important part of capitalism is not just about production, but about consumption, market exchange, and commodification. Polanyi is optimistic in the sense that he believes society is able to wage collective action against the commodification of labor, land, and money— against bankers and rentiers. Do you think his optimism is warranted? Or do you think the politics around capital realization are much more problematic than what we had imagined?

DAVID HARVEY The main difference between Polanyi and
Marx on realization is that Marx spends a lot of
time talking about two kinds of consumption.
One is final consumption, which is what you
and I participate in, and the other is what
he calls productive consumption, which is
investment in infrastructures. In the Chinese
case, it's not consumerism that is driven in the
realization process, it's productive consumption,
which creates new fixed-capital investments
and infrastructures. It's a different kind of
consumption that is supposed to improve
productivity. (*Pause.*) The question is:

*Are all the investments that have been
made contributing to productivity?*

AUDIENCE [*LAUGHTER*]

DAVID HARVEY Fifty percent of the Chinese economy has been
driven, particularly over the last five or six years,
by investment in physical infrastructures—
25 percent alone by housing. It's not clear to
me that a 50 percent investment of your GDP in
that kind of productive consumption is getting
a good rate of return when the rate of return, in
terms of the growth of the Chinese economy, is
now sinking to around 6 percent—some people
think it's much lower. So productive consumption
runs out because you're creating fixed capital for
something that doesn't arrive. (*Pause.*) Look at
Ciudad Real, south of Madrid. It's one of these
speculative building projects. They built a new
airport to which no planes have flown. They had
a two-billion-euro airport sitting there doing
nothing. Last summer they tried to auction it off—
the top bid was 10,000 euros.

DAVID HARVEY The building of the airport is an example of
productive consumption—but it has not been
realized by planes flying there and using it.
Marx was very aware that consumption is about
productive consumption *plus* final consumption.

AUDIENCE [*LAUGHTER*]

AUDIENCE [*LAUGHTER*]

AUDIENCE You talked about the idea of the spatial fix, and
 working with surplus capital. You also talked
 about going from Haussmann to American

DAVID HARVEY And Marx was also very aware—in ways that
 Polanyi was not quite clear about—that when
 extracting surplus value from laborers, the
 payment to laborers tends to go down. And if
 the payment to laborers goes down, as it has
 done since the 1970s, then the market, in terms
 of consumer demand from working people, is
 basically stymied. (*Pause.*) But I always liked
 Polanyi. His work was a helpful way station en
 route to reading Marx. I used to disguise my
 Marxism by saying I was quoting Polanyi when
 I wasn't.

DAVID HARVEY I had all these great disguises. I first started
 teaching *Capital* in a geography program at an
 engineering school. (*Pause.*) And for five years
 the central administration thought I was teaching
 a course about capital cities.

AUDIENCE suburbanization to what China is doing, in
which we see a scale change, a huge scale
change. (*Pause.*) This scale change is disturbing
to me because I am a believer in the law of
dialectics—quantitative changes leading to
qualitative changes. What do you see as the big
macroeconomic threat with this scale change
that we are witnessing in China's surplus capital
investment?

DAVID HARVEY If the United States is not as hegemonic as it
once was, how are we going to think about a
hegemonic center within the dynamics of capital
accumulation? There are many signs that it is
breaking apart into regional hegemons, so that
Germany, for instance, doesn't take much notice
of what the United States says anymore. (*Pause.*)
In the history of situations where there are
regional hegemonic configurations rather than
a single global hegemonic power, actors tend to
go against one another. And that's typically led to
global conflicts and global wars. Geopolitically,
we're seeing some of the consequences of that
phenomenon in the Middle East right now, with
Russia versus the United States versus the
European Union. (*Pause.*) So the scale problem

DAVID HARVEY of how capital is working is such that we need
global regulation on many levels. We need global
regulation of financial flows. We need global
regulation to deal with issues like climate change
and species extinction and habitat destruction.
The really serious stuff that needs to be done
is not being done. So you may be saved from
being up to your neck in cement by being up
to your neck in water, thanks to sea-level rise.
(*Pause.*) Five or six years ago, I went to Brazil
for the first time since the 1970s. Some of the
cities I knew are now unrecognizable. You come
in on a superhighway; you've got condominiums,
mega-shopping centers, high-rise stuff going on.
This is the style of urbanization that we're now
seeing all over the place. My favorite example is
São Paulo, which rests on automobile production
as its economic base. They produce a load of
automobiles that then sit in traffic jams for hours
on end. (*Pause.*) And if you say:

> *This is not a very sensible economy;*
> *this is insane! Why don't you stop*
> *producing automobiles?*

They'll respond:

> *Well, if we stop, the economy*
> *will collapse.*

DAVID HARVEY Then you ask:

> So are you going to produce even
> more automobiles?

And they'll say:

> Yeah, we're going to expand the
> automobile industry as much as
> we can.

And we ask:

> Well, are they going to go?

That's where traffic engineers come in. They've got to engineer it in such a way as to get 15-lane highways through the center of the city . . . I'm sure you'll enjoy living in that environment. (*Pause.*) The hegemony question is a big one. And unfortunately, the left doesn't have any particular answer to that. The left is obsessed with local initiatives. People misinterpret me when I say that, as if I'm against local initiatives. I'm not. Pretty much all politics originates from local initiatives. But if it originates and stays local, that's a problem. The challenge is to scale up the politics to something different. And the left has not been thinking about that sort of thing very much. (*Pause.*) I have a lot of admiration for what the anarchists and autonomistas are talking about. But I have profound disagreements with them when it comes to how to scale up and what should happen when you scale up.

AUDIENCE What are the origins of this ideological mess
you're talking about? Which institutions can
help us to historicize and understand what
is happening?

DAVID HARVEY My version of it is in my book *A Brief History of Neoliberalism*. In the early 1970s it was clear that corporate capital and the wealthy classes felt deeply threatened by what was a certain decline in their wealth. There was a feeling that there had been a power shift toward labor. Look at the legislation that went through Congress under Nixon, and got signed by Nixon—it created the Environmental Protection Agency, OSHA, consumer protection laws; there was a whole raft of legislation that was curbing capitalist class power. (*Pause.*) That is when they decided that the universities should be surrounded by think tanks producing alternative information. And that's when they founded the Olin Foundation, the Manhattan Institute, the Heritage Foundation. All the foundations were set up by big capital. The stance was that if you want good education, you've got to pay for it. (*Pause.*) There was a huge ideological fight on that level. And then individualism and Reaganism and Thatcherism

DAVID HARVEY came in. They co-opted the Swedish bankers to create something called the Nobel Prize in Economics, which they promptly gave to Friedrich Hayek and Milton Friedman. (*Pause.*) This was an institutional response to what was felt to be a desperate situation on the part of corporate capital and the capitalist class. And they were, of course, successful. (*Pause.*) Now, a lot of that success is breaking apart. We're increasingly put in situations where we have no choice but to act in a neoliberal way. Clearly, we are all neoliberals without knowing it; a lot of our decision-making is constituted in such a way that there is only one way we can go. (*Pause.*) It's going to take a big change of mentality to bring back some notions of communal action, communal solidarity, which is why I like a lot of the local initiatives that talk about urban commons, and many of the attempts to create what you might call unalienated spaces in a sea of urban alienation. But changing the mentalities of entire populations is going to be extremely difficult. We think radically differently now than we did in the 1970s. And even I find myself being neoliberal on occasions, particularly when I look at my pension fund . . .

AUDIENCE [*LAUGHTER*]

AUDIENCE [*LAUGHTER*]

AUDIENCE Your lecture is very well placed in the sense
that we find ourselves in a space where political
subjectivities, as you put it, are being firmly

DAVID HARVEY Pension funds are invested in the stock market. So if you crash the stock market, everybody's pension fund goes under. There's a vested interest in saving the stock market. This is a very good example of bad infinity because the central bank simply adds zeroes to the money supply with quantitative easing; the money flows into the stock market, and a jacked-up stock market is great for my pension fund. So I benefit from that. But at the same time, I don't want that spiral to happen. We all get internally conflicted about things like that. So as a real revolutionary, I should want to say:

> *Let's close down the stock market,*
> *let's really wreck the stock market.*

And then I kind of go:

> *Oh, my god, my pension fund.*
> *What will happen?*

AUDIENCE cemented by the sheer force of the debt that we
 accumulate. My question is about the spirals—
 the macroeconomic spirals that are getting out of
 control. Where would be a strategic place to start
 attacking, dismantling those spirals? And what
 role could the university play in that process?

DAVID HARVEY I just came back from Brazil, where I was
supporting the mayoral campaign of Marcelo
Freixo. "If the city was ours" is the slogan of the
campaign. Movements of this kind can become
small tremors and then major earthquakes. Or
they can just become small tremors, and that's
it. But there is something going on at that level
in many parts of the world that is encouraging.
(*Pause.*) But spaces are changing very fast. And
you don't know where the crisis is going to hit
next. You don't know which country is suddenly
going to declare that it's close to bankruptcy.
It's a very volatile situation. Nobody in Turkey
expected the Gezi Park protests to occur. Gezi
Park was a process. Unfortunately, it triggered
another process by President Erdogan, a process
toward a totally autocratic, rather brutal police
state. Which is not being challenged at all by the
European Union because Turkey is housing about

DAVID HARVEY two million Syrian refugees. In order to keep
them there, the European Union is not saying
anything about the fact that people who signed
a letter that was just talking about negotiating
with the Kurds lost their jobs and, in some cases,
are being prosecuted. More than 1,500 academics
are under suspicion or under arrest. We know,
at the same time, that certain cities or towns in
southeast Anatolia are being put under martial
law; nobody is allowed on the streets. People are
actually starving to death in some of those towns.
The Kurdish question has become a violent one.
(*Pause.*) Nobody would have predicted this two
or three years ago. But again, capital is often
very good at being flexible and adaptive. And
that's something that the left needs to learn
from capitalists—how to be adaptive and adept
and fast in its strategies. In fact, the left is very
conservative. My Marxist friends are stuck in the
mud a lot of the time. It's chronic. The dynamic
part of the left is more likely to be the cultural
producers. The people who launched the Gezi and
Brazilian protests came out of the cultural sphere.
Again, the politics of realization were involved
there, rather than the politics of production.
(*Pause.*) I have a hard time getting people on

AUDIENCE What would it look like to have a society and an economy organized around good infinities rather than bad infinities?

DAVID HARVEY the left to recognize that the politics of realization is where we should be mobilizing. I'm not saying the politics of production are irrelevant. But we've got to create alternative politics. And I haven't seen that emerging very much in Europe, except recently in Spain.

DAVID HARVEY I've always been a secret fan of Murray Bookchin's writings on urbanization. Which is not to say that he was a nice guy or anything, because he wasn't. But his idea about municipal organization and confederal socialism seems to be one of the ways in which one can start to organize around the politics of realization. (*Pause.*) One of the strengths of the Podemos party in Spain is that they grew out of assembly-type reconstructions of political organization and political power. They are still rooted in that, even as they've gone national. How that rootedness is being maintained, I'm not quite sure. And I always fear that the rootedness will get neglected and disappear. (*Pause.*) Something similar is

DAVID HARVEY happening in Rojava, for example, where the
Kurdish PKK is organizing decision-making on
principals of assembly structures. This is partly
coming out of Bookchin and partly out of the
experience of the Zapatista movement. (*Pause.*)
In cases like these, there emerges a form of
sociality that is radically different from the sort
of possessive individualism that dominates in
a neoliberal world. We see that particularly in
the wake of disasters of various kinds. When the
people who are involved in the Occupy Movement
in New York rallied around trying to deal with
the aftermath of Hurricane Sandy, they did a
faster and better job than any of the official relief
services. (*Pause.*) Unfortunately, the tendency
is toward a reconstruction of the existing social
order, rather than a transformation of political
consciousness on the part of the people being
helped. Occasionally things happen in a different
way; people start to say things like:

*Well, we don't have to do it this
old way; we have alternatives.*

It's possible to talk about utopian alternatives.
It's very good that people have utopian designs.
But the best teacher is experience. (*Pause.*)
For instance, Turkish colleagues have said

AUDIENCE It seems inevitable that human population will
increase by several billion over the next few
decades. This fact is used as a justification for
a *grow, grow, grow* mentality. You didn't map
population growth onto your critique of capital.

DAVID HARVEY that the experience of participating in the Gezi process made a radical difference in how they thought about themselves in relationship to the society around them. I think this was true of the Occupy Sandy people too. There is a growing consciousness that we don't have to do things in a completely neoliberal way—we can do things on a much more collective basis.

The population growth issue is an important one. One of the best ways toward population stabilization is the education of women. Any country that develops an elaborate approach to the education of women experiences tremendous shifts in demographics. That's one feature of any social order that is crucial. (*Pause.*) But in many parts of the world, like Europe and Japan, we're at zero growth. The case of Germany is fascinating. There's going to be a real problem, again, because the working population is diminishing

DAVID HARVEY while the older population is growing. There's a
pension crisis coming up. And the obvious way to
resolve it would be to let the Syrians come in and
bolster the population. A lot of people didn't want
to welcome immigrants. But Angela Merkel said:
We need the labor, so bring them in.
And that then generates all of the negative stuff
about immigration. (*Pause.*) A stable population
is going to be just as necessary as a stable
economy. But that doesn't mean that we have
to keep on growing to accommodate a growing
population. In fact, it's the other way around,
as far as I'm concerned. It means that certain
parts of the world have to learn to deal with
less. (*Pause.*) We can start here in the United
States. How much consumption is complete junk
in this country? I'm not against consumption,
but we could do with much less, with an actual
improvement in quality of life rather than a
diminution of quality of life. (*Pause.*) About a
third of the Christmas presents bought in this
country are never used. Most of them are junked
immediately. Why don't we stop buying all those
Christmas presents? Find a different way to give
a Christmas present—something like: *Be nice
to somebody.*

AUDIENCE [*LAUGHTER*]

DAVID HARVEY Wouldn't that be nice? *Give somebody a hug.* Give them five hugs. And if you're really fond of them, give them ten. (*Pause.*) Let's leave it there. Thank you all very much.

urbanNext associates journals topi

The Insurgent Architect

Daniel Ibañez | David Harvey | Mariano Gomez Luque

Harvard Graduate School of Design, March 29th, 2016.
A version of this interview will also appear in David Harvey, Abstract from
the Concrete, the third volume in "The Incidents' series, copublished by the
Harvard University Graduate School of Design and Sternberg Press, to be
released in September, 2016.

Mariano Gomez Luque | Daniel Ibañez Your writings touch an
important nerve for us, as architects. They represent a powerful effort
to understand the dynamics of capitalism in spatial terms. Your work
is an invitation to critically exercise our imaginative powers, and
simultaneously a call for action—for finding ways to translate into the
domain of space socio-organizational forms that could challenge
those already set, defined, and crystallized by the capitalist machine.

Can you tell us more about your personal relationship to the design
disciplines? In your most recent book, *The Ways of the World*, you
write: "As an urbanist the whole question of architecture and the role
of planning was never far from the surface of my thinking." Can you
elaborate?

David Harvey I have always been interested in the question of the
production of space, and have been writing about it for many years.
The discourse has a long tradition; some people think that it was

formats gsdpublications | Out 🔍

frica africanCities Architecture

rchitecture's challenge Architect's role Building

uilt environment Challenge City Concrete

ultural agitator Culture Design Discipline

nergetic Approach Energy Facilities Future cities

uture development Future tendencies Housing

nfrastructure Local economy Local resources

Megacites & High Density Natural dialogue

hotographic Atlas of the Cities Photography

olitical & Economic Approach Public buildings

ublic Space Public space role Social commitment

ocial contributor Social culture Southern Coexistences

production of space, and have been writing about it for many years. The discourse has a long tradition; some people think that it was invented by Henri Lefebvre, whose 1974 book, *The Production of Space*, grounded much dialogue, but it was not. In fact, many urban planners from the 1960s, like John Friedmann, were linking planning with the production of space in parallel to Lefebvre's work.

Spatiality has a very expansive meaning for me: there are relative spaces, relational spaces, absolute spaces. These nuances are crucial to understand if we are to have a stronger connection with the ways in which things get shaped on the ground—this wall here ... those steps there ... a bridge over there ... All of these relative spaces of the city are constantly being produced and reproduced. Then there are symbolic spaces, which have both a relationality and a meaning that are far greater than their mere physical manifestations. Many of these symbolic spaces have the power of a certain centrality, which we see exercised politically in cases like Tahrir Square in Cairo in 2011, or in the Occupy movement in New York. I'm interested in these manifestations, and of course, in the people who are making the walls—the engineers, the architects.

During the 1960s, many architects considered themselves urbanists. Even people like Rem Koolhaas (who I'm not a great fan of) were participating in exciting debates at the Architectural Association in London, where there was a social sense about cities. I gave some lectures at the AA back then, and talked with architects—among them Richard Rogers—who were interested in the urban. Later, regretfully, people became exclusively concerned with building activity, and consequently forgot about the urban context.

Architecture is a world that I have always been close to, because architects have a view of space, although theirs is rather different

ublic space Public space role Social commitment

ocial contributor Social culture Southern Coexistences

ustainability Technological Approach

erritorial Approach Urban conditions Urban culture

rban environment Urban infrastructure

rban pathologies Urban planning

Architecture is a world that I have always been close to, because
architects have a view of space, although theirs is rather different
from mine. Sometimes we have conversations in which we think we
are talking about the same things, but we are not. It's a challenge, in
the sense that there is something to be learned from this discordance.

> **MGL | DI** In *The Ways of the World*, you refer to your participation
> as a jury member, together with architects and engineers, in an
> international competition for a new city in South Korea. Could
> this episode be understood as your way of actively becoming an
> "urbanist"? Could you tell us more about that experience?

DH We were in charge of making a judgment about the projects
submitted to the competition. It was a very peculiar experience. I
thought it was an opportunity to do something experimental. I had
read a lot of what fellow jury member Arata Isozaki had written, and
was very attracted to his ideas about urban form. I was openly against
creating determinations—spaces limited by fixed form and program;
on the contrary, I wanted to see how different aspects and variables of
projects interacted at the level of the social, and how they addressed
nature, technology, production, employment, and political
subjectivities.

In the end, the jury did not select a winner; instead we selected a
group of projects whose authors were supposed to continue
developing and consolidating their proposals. It was an interesting
learning experience, getting the engineers' perspective. I was a little
shocked by what the architects on the jury had to say; they were
mainly interested in a discussion about the symbolic qualities of
circles and squares.

> **MGL | DI** Did you find a common ground for communicating with

MGL | DI Did you find a common ground for communicating with architects in the context of the jury deliberations?

DH Everybody seemed interested in what I was trying to say, in the elements of my criteria for evaluating the projects. But of course some people were horrified when I said that many of my ideas came from Marx. They said: "What!?" That's often a conversation stopper. People usually get caught in the ideological trap (whatever we may mean by that) when talking about Marx, often ignoring the power of his theoretical framework of understanding.

MGL | DI Historically, interventions by architects and urban designers and planners have been circumscribed to what we traditionally call urban zones. However, as you have pointed out, the "urban" is undergoing a radical change of scale; it now operates at the level of the whole surface of the planet. Your work has challenged divides like society/nature or urban/rural, opening up new spaces for design intervention beyond cities. Do you see emergent spaces where designers can effectively contribute to more socially just and ecologically sane environments? What do you think are the key problems to address—or illuminate—through new research?

DH I am increasingly interested in the politics of daily life, to the degree that the qualities of daily life are partly embedded in the nature of the environments we construct. This entails a constructivist kind of approach. Without being environmental determinists, we could say that as we create environments, environments create us. This is part of what I call dialectical utopianism, a condition that I hope architecture practice can situate itself within.

MGL | DI In *Spaces of Hope*, you talk about the figure of the

MGL | DI In *Spaces of Hope*, you talk about the figure of the architect, in both a metaphorical and concrete sense, as an agent who can create and discover "spaces for new possibilities." One of the most contradictory dimensions we confront as architects is the fact that, regardless of our role as "creators of space"—perhaps a naïve claim after all—space is actually the outcome of forces beyond our control, capitalist, institutional, or political forces. How do you see this contradiction?

DH Well, I don't know, that's for you to worry about! (Laughs)

It's a real dilemma. I can, in fact, talk about the production of space, only to see later how what I say gets co-opted by capital. The same applies to architects, at least to those who have social consciousness and try to work in a progressive way. They may see that their work gets co-opted by capital, and therefore may feel that in some way they contribute to the reproduction of this logic without wanting or intending to. And although architects are not alone in this, they do have an advantage, because they know what the implications are when a developer says *you have to do this*, which clearly exposes who is ultimately in charge of the process of the production of space. At that point, the creative architect, or what in *Spaces of Hope* I call the "insurgent architect," has to think about how to subvert this power relation: How can you use the knowledge and the technology at your disposal to achieve goals that are different from, or alternative to, capital's goals?

It is important to understand that given the power of capital in shaping the construction of the built environment, strategies of subversion are needed. In that sense, architects can be more confrontational; they can sit across the table from developers and oppose them.

confrontational, they can sit across the table from developers and oppose them.

MGL | DI In the last 40 years, we have seen how, with the rise of neoliberalism, architecture has become a form of spectacle in itself; buildings have turned into a kind of luxury commodity.

DH It all depends on which part of the world you are in. Most of the so-called starchitects went to work in China because they thought that there were no constraints there. But Alejandro Aravena, for instance, is approaching the question of housing in a form that is more progressive than I have seen in other places. I think his idea of building a basic structure that you can later update, or complete more or less as you want, is a good idea. It's not radical, but at least it's open, and allows the participation of the inhabitants, mixing social governmental action with a more traditional self-building approach. That concept is not new, it came out of radical anarchist thinking, and is now being appropriated by the World Bank in what I think is another example of a good idea that gets co-opted by capital.

MGL | DI Do you think that design disciplines can devise strategies of opposition to the relentless pace of capitalist urbanization?

DH In Uruguay, people have set up cooperatives to build their own houses, investing either through labor or with actual money, and they have produced very high quality housing. They are now reactivating some abandoned buildings in downtown Montevideo, refurbishing them and turning them into housing. These are modest but very good examples of alternative ways in which communities can participate in the building process. You can see a clear connection between the logics of production and the politics of realization.

logics of production and the politics of realization.

MGL | DI Architecture seems to be an organic component of the capitalist tendency toward endless growth. It's still largely driven by building activity, by a process of construction understood in a positivistic way. But there have been recent attempts to rethink the agency of architecture in terms of "unbuilding" protocols —mechanisms of building subtraction and preservation. Do you see these as effective strategies of resistance to capitalist urbanization?

DH Everything should be on the table. Today more than ever we need to think both politically and socially about the city; these dimensions have been buried under the process of urbanization, which is basically anti-city. This process works against public space and urban life in an effort to turn the city into a tool of capital. In this regard, there are various strategies to reconstruct the city on the ruins of capitalist urbanization. One is to create spaces that can assemble political expression, and which can liberate the public from typical strategies of enclosure.

Is it still possible to introduce various commons into the city, and if so, how? The objective here is to create a sense of the city as a totality that has both a social and a political meaning that people can act upon, feel comfortable with, and have dialogue and even conflict within. We should be open to new possibilities, as opposed to continuing simply filling in spaces, following an endless impulse for growth.

MGL | DI Increasingly, design schools are in need of new frameworks of understanding in order to unpack the complexity of urbanization processes as a precondition to design

of urbanization processes as a precondition to design
intervention. At the GSD's Urban Theory Lab, we have been
developing the conceptual framework of "planetary urbanization"
under the guidance of Neil Brenner. Planetary urbanization builds
upon Lefebvre's hypothesis of the total urbanization of society,
updated as complete urbanization of the world, surpassing the
idea of the city as a distinct urban form. What do you think about
merging critical urban theory with design as part of a
multidisciplinary effort?

DH It is crucial to come to terms with the dynamics of urban
processes as they exist right now. We cannot continue to think about
the city as an isolated terrain. It has been stunning to see social
movements, like Gezi Park in Turkey or the Brazilian Spring, become
system-wide, rapidly spreading to other cities—cases like the antiwar
protests on February 15, 2003, when millions of people were in the
streets in a few hundred global cities, opposing the Iraq War. I
remember being in Athens the night of the occupation of Syntagma
Square. One of their slogans was borrowed from the Indignados
movement in Spain, something like: "Why is it taking you so long?"
There is a kind of a contagion among cities, and an increasing global
awareness about these movements.

Politically, the urban network is not only a capitalist construction;
there is also a sense of the urban that is not clearly articulated, and we
cannot know when it may be invoked or suddenly erupt. I don't think
anybody could have predicted what happened on February 15, 2003. It
was a shock, and it changed politics. We can now imagine that a
project that we are undertaking in a particular place or city can have
effects on other cities and places, through what we may call relational
spaces. This relationality is intangible, or as Marx said about value,

spaces. This relationality is intangible, or as Marx said about value, immaterial and supra-sensible, but objective. A lot of politics are intangible and supra-sensible, but have objective consequences.

MGL | DI Your famous dicta "It is, in practice, hard to see where 'society' begins and 'nature' ends" and "There is nothing unnatural about New York City" have been very influential for new Marxist work that is often described as urban political ecology. The work of scholars in this field engages with the long overdue task of reinserting questions of nature and ecology into the urban debate via a historical materialist analysis of urban flows, such as water. How can the analysis of a particular material flow help untangle the economic, political, social, and ecological processes that form contemporary urban landscapes? How, for instance, can studying the consumption rates of cement, as you described at yesterday's lecture, help scholars unpack urban complexities?

DH At the beginning of *Capital*, Marx talks about "concrete abstraction," and so I thought that it would be interesting to "abstract from the concrete." (Laughs) I think the purpose of the general theoretical frame is to create a cognitive map around what it is you are trying to do and how you are trying to do it. When you actually start doing these things, you often find that you can't possibly do them all. But there is a distinction between people who go and focus on details without having a general map, and those who struggle to create such a map.

In my work, I try to be conscious about how details connect with this cognitive map. William Blake said something along the lines of the truth lies in a grain of sand, a notion in which everything converges. I see a big difference between students who deal only with the grain of sand, and students who focus on how the grain of sand is internalized

see a big difference between students who deal only with the grain of sand, and students who focus on how the grain of sand is internalized within many other forces, even when you can't possibly track all of them. You have to contextualize your work. And you have to speculate. This can't be all hard science and hard information; you can get hard science and hard information about particular things you are working on, but those facts look different when you pull back the telescope and look at them in the context of the broader picture. This is the moment when the fun comes in, the moment of speculation.

MGL | DI Indeed, our work is usually confined to the "grain of sand," whether we like it or not. But even the most discrete intervention is tensioned and incorporated into myriad material, social, political, economic forces. In this sense, we wonder where you think design agency lies in terms of facing the complexity of capitalist urbanization critically as well as operatively.

DH I think designers have a great deal of experience in shaping environments and spaces in surprising, unexpected manners, or in ways that open possibilities that were not there before. In that sense, designers *do* have agency, but I think this agency is circumscribed by political and social context.

In the current conjuncture, for example, I don't think that the only valid form of intervention is related to organizing public participation. There are instances in which you have to be more subversive and underground, so to speak. Democratization is fine, but when you have a population that has only one thing in mind—like, "private property is sacrosanct and that's it"—and you are interested in talking about collective forms of design, you may not get away with what you want to do through public participation. Therefore, you may want to find ways to demonstrate how different collective forms of living or

to do through public participation. Therefore, you may want to find
ways to demonstrate how different collective forms of living or
working have something to offer. You may have to go against
prevailing public opinion. As Gramsci elaborated, there is "common
sense" and there is "good sense." Radical social consciousness is good
sense. We may find that very often the common sense of the
population is neoliberal, individualistic, private property-driven sense,
and if you go with your idea of public participation, people may simply
want to create something like an American suburb.

Agency is about creating, or opening, alternatives. People learn from
experience: if you can create an urban experience that is radically
different from that which is the convention, then the common sense
over here will start looking at the good sense over there.

Leave a Comment

Your Comment

SUBMIT COMMENT

MARIANO GOMEZ LUQUE is a practicing architect from Argentina. He holds an MArch with distinction from the Harvard University Graduate School of Design, where he is currently a doctor of design candidate. He is a research fellow at the Office for Urbanization and the Urban Theory Lab, as well as editor of *New Geographies*. As director of the Office for Infrastructure Space, his research focuses on alternative modalities of design practice, especially in relation to the problem of the production of space under contemporary capitalism.

DANIEL IBAÑEZ is a practicing architect and urbanist, and founder and codirector of the design firm Margen-Lab. He holds an MArch from ETSAM in Madrid, an MAA from the Institute for Advanced Architecture of Catalonia, and an MDes in Urbanism, Landscape and Ecology with honors from the Harvard University Graduate School of Design. He is currently an instructor and doctor of design candidate at the Harvard GSD, editor of *New Geographies*, and researcher at the Urban Theory Lab. Ibañez's research seeks to frame the design disciplines in relation to broader socio-ecological interdependencies.

DAVID HARVEY
Abstract from the Concrete

Published by the Harvard University Graduate School of Design
and Sternberg Press

ISBN 978-3-95679-261-8

HARVARD UNIVERSITY
GRADUATE SCHOOL OF DESIGN
48 QUINCY STREET
CAMBRIDGE, MA 02138
GSD.HARVARD.EDU

STERNBERG PRESS
CAROLINE SCHNEIDER
KARL-MARX-ALLEE 78
D-10243 BERLIN
STERNBERG-PRESS.COM

DAVID HARVEY began his academic career as a Marxist geographer, later extending his work into the realm of the urban, with a focus on social justice. Over the past 40 years, he has developed a close reading course on Marx's *Capital*, now openly available as video lectures. This pedagogy is accompanied by in-depth writing on Marx in works such as *The Limits of Capital* (1982), *The Enigma of Capital* (2010), and *A Companion to Marx's Capital* (2010/2013). His most recent book, *The Ways of the World* (2016), is a collection of essays that span his career, describing his trajectory as one the most radical geographers and social theorists of our time while unpacking core concepts for understanding the deep links between class, urbanism, social justice, and capitalism today.

Harvey is currently Distinguished Professor of Anthropology and Geography and Director of Research, Center for Place, Culture and Politics at the Graduate Center of the City University of New York. In 2015–2016 he was the Senior Loeb Scholar at the Harvard University Graduate School of Design.